NORTH WAS HERE

ELLIE GA

D0864165

Ugly Duckling Presse, 2018

Arctic Booklets
(c) Ellie Ga, 2018

ISBN 978-1-946433-14-5

First Edition, First Printing, 2018
Edition of 800

Ugly Duckling Presse
The Old American Can Factory
232 Third Street, #E-303
Brooklyn, NY 11215
<uglyducklingpresse.org>

Distributed by DAP|Distribued Art Publishers

This book is part of a constellation of works entitled
The Fortunetellers, which includes a performance
of the same name, a series of videos including "At
the Beginning North Was Here," bespoke cards used
in the performance "Reading the Deck of Tara," as
well as numerous photographic series and drawings
including the ones reproduced in this book.

Ten Till Two (10:10), Snow Walks, and Drift
Drawings were first published as "Three Arctic
Booklets" (UDP, 2010), in an edition of 50.

Special Thanks to Tara Expéditions,
Gabrielle Giattino & Bureau, New York.

Designed by Don't Look Now! with the author
Printed at _____
Covers letterpressed at UDP

Contents

TEN TILL TWO (10:10)

At the beginning north was here. But it
keeps changing. That's where we were. This
is our world. We had a couple of trips
outside of this map but not maybe more than
four days altogether. These are pressure
ridges. I tried to name them after things I
know, like the national mountain of Norway.
There is another one over there. And that
one doesn't have a name.

This is the area where the polar bears used
to hang around. They hung around for a
week. Around some hummocks. A hummock is a
big pile of ice.

That's Tartu. That's Helsinki. Copenhagen is
not here. It broke up when we were building
the runway.

It's not a long time ago that we saw our
last bird. For us, a bird is like a big
plane.

So where is New Helsinki? I keep thinking
New Helsinki is over here. No, St. Petersburg
is over here. This is almost melted. A lot
has disappeared. It is a world that moves
fast in fact. Like right now. During the
summer the boat's position was north-this
way. But that doesn't matter.

Tromso, Helsinki, they don't exist? Yes, they
exist for me.

In fact, St. Petersburg is not there. It was
just a visual moment.

Is there a name for this area? I'm not sure.
Why? Because it is not there.

South was there. That's the limit. It is
important and not important.

They never did replace Helsinki. We never
put it back. It was never here.

So there is no New Helsinki after all.

A question mark? Does that represent the big idea?

Bad shovels. Bad organization, but they all survived. We can be optimistic. How long ago was that expedition? A hundred years? That boat was wood. Ours is aluminum. Wood breaks. Aluminum bends.

This is a map of the future. With a little bit of the past.

The furthest I have been from the boat
was a few kilometers. The visibility was
good, we could see the boat. But after 10-
15 minutes, the visibility changes and when
the boat disappears it is as if our star
disappears. But it's good when this happens,
when the visibility changes, because you
have the impression that you are really far
from the boat even if you are only 2 or 3
km from the boat. You have the impression of
really being far.

Here we are near the top of the world.
That's the door to the exterior. Bottles of
gas, the sauna, kerosene drums, the ropes,
the snowman, the toilet, the moon and the
snow. It's like we are on the moon looking
at the earth. That's the wind which blows on
us. We don't know the destination.

For me, now, the north is empty. Nothing
there. One time I had shooting practice
facing north. That's about it. The wind
blows and blows from the north, which will
one day blow us home. I don't like that
idea. I prefer to stay here.

Chaos, the big hummock. Paris has changed.
Now Paris is bigger.

You've been there. I've been there.

Paris turned into an airport on the eastern
extreme of the validation line.

Chaos has disappeared.

We slid by the North Pole. During the
summer, the boat was very close to the pole.
I don't remember how close we were, how many
kilometers exactly, but one day we were very
close and the next day we were far away
again. Everyone was disappointed. Everyone
wanted to get farthest north. We were going
to ski to it but it was too difficult, too
far. But whenever we went out for a walk we
would always head north.

North. South. East. West. It's different

each time. I'm just trying to search the archives of my memory. We often use the word ephemeral: our life here, our passing, everything is being erased behind us and even our memory is being erased as our world has gotten smaller and broken up. Our world is gone.

Here is the boat. And here is the wind.
And this is the zone I often called our
garden. That is our world and it has shrunk.
Helsinki didn't last. It was moved over. We
called it New Helsinki. This one here is
Wellington.

The limit was further. But not much further.
Just behind the toilet.

The points in the distance were the
validation line. The validation line is a
1 km line. We need to validate our world
because we are not sure it exists.

North was here. Over here somewhere. Our ice
block always stayed at the same position,
then we went across the top and north
became south and south became north. It
doesn't really make any difference to our
life. At least we weren't drifting sideways.

This is the one moving now, the remnants of our ice block. Where we peed or where we used to pee. It's all melted away now. This was later on. Tartu is now over here. The validation line is broken in half.

I call Charles de Gaulle airport Liban-
Lebanon. Because Charles de Gaulle airport
is the only place in France with a Lebanese
cedar. When I go there I can see it from the
highway. There is just one. I remember it
from when I was a child.

There's the radiometer. If I could see,
it would be easier. Tartu is dead. The
black box was at Tartu, which recorded
the information, just like the one on an
airplane. A mermaid for Copenhagen. Berlin
represents where the bears used to stay.
This is New Helsinki, the beginning of the
line. But I thought that no one knew it
was called Helsinki, so they renamed it St.
Petersburg. New Helsinki and St. Petersburg
are not the same place. Now we have both St.
Petersburg and New Helsinki.

That's the reception from the iridium phone.
It's a complex world in terms of everything
you don't see.

I'll put the boat in the middle because it's our house. Here's the fire for burning the rubbish and here's the toilet. Here's a piece of ice, like a mushroom, under the boat. When we dive we wake the little fish up. I saw a lot of beer cans down there.

Here's the old lead and a little tent. The other one disappeared.

It wasn't possible to walk around here then. Paris here. Charles de Gaulle airport there. The first airplane arrived here. Then another one. I arrived here with the first airplane. Then I took another airplane to get to the boat because we couldn't cross it then on foot.

In the summer, first we got around with skis, then with rubber boots, then with a life jacket. The world changed a lot back then, every week. I'm happy that the

situation evolves. There is nothing I miss. I'm content to see the stars now. In the summer it was always the sun and after five months the day is finally finished.

Ten people are put into an unknown room for one minute, maybe a little less, not more. Then they are asked to describe what they have seen. What do they remember? The descriptions are very different for each person. Nobody sees the world in the same way. We don't have another picture world. We must see only what we can see, not more. Not more.

NOTE

I arrived on Tara when she was locked in the
ice at approximately 86°N, 12°W right before
the sun set for the long polar night. Before I
had left for the expedition I was told I should
prepare to be aboard for at least six months.
Upon arrival, predictions were that we would
drift so fast that we would be out of the ice
in little over a month. I felt that I had come
to the party too late and that I would never
get to know the ice in the same way that some
of the other nine crew-mates understood it. It
was all just a lot of ice and snow to me.

I ask my crew-mates to draw me maps of our
world; no two maps are alike. I record their
narrations as they draw their maps. Of course
there are some common references, like the boat
or the toilet or the shared place names used to
identify the science stations. But on some of the
maps there are places that only one person has
named — or has noticed. And of course the longer
a person has been here, like in most places,
the more there is to see and to point out.

And there are differences. Just the other morning the captain and the carpenter caught a glimpse of my own map and they began to correct some of the orientation. They wondered why I had written silence under the area in my map labeled south. South is the silent area, where we are headed, the future for me is silent. For the captain, who has been here for over a year now, the south is noisy — filled with people and commitments. The mechanic disagrees and on his map he too writes the word silence under the area labeled south. But regardless of what we imagine for the future and what the future might sound like, there is actually no silence up here — despite what everyone down there thinks.

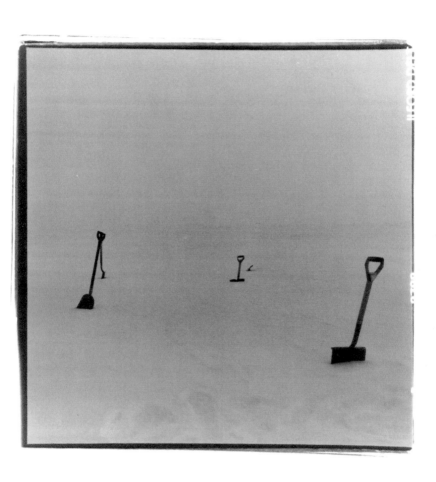

DRIFT DRAWINGS

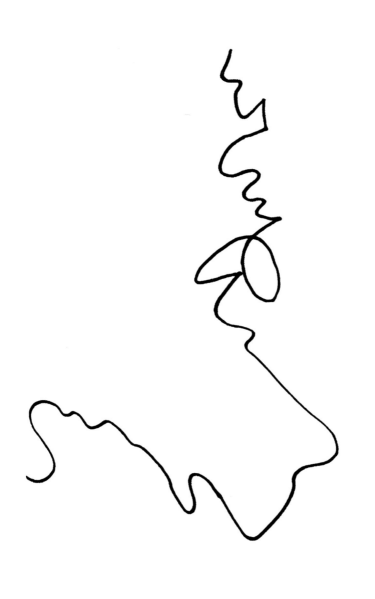

OCTOBER 1

OCTOBER 8

OCTOBER 15

OCTOBER 22

OCTOBER 23

November 8

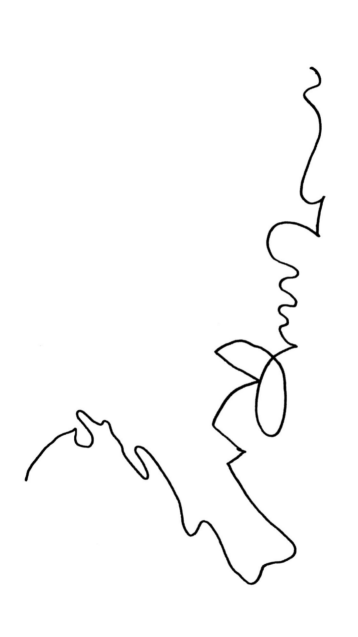

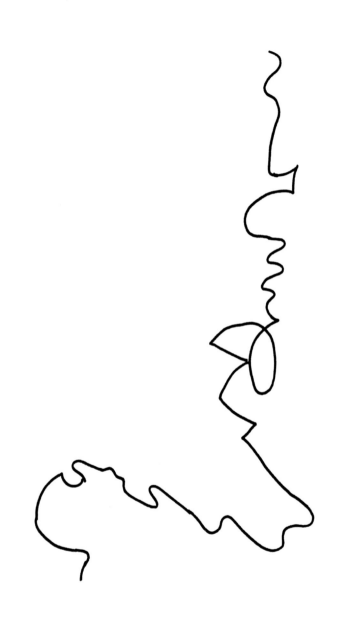

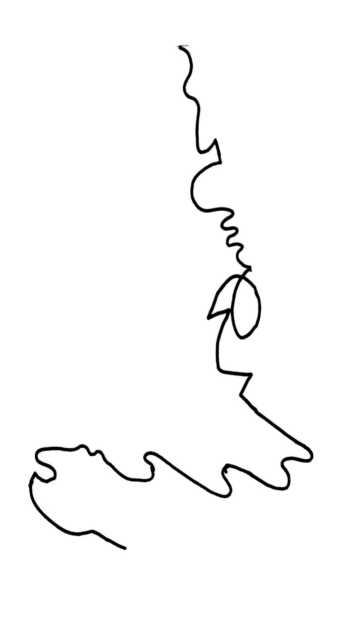

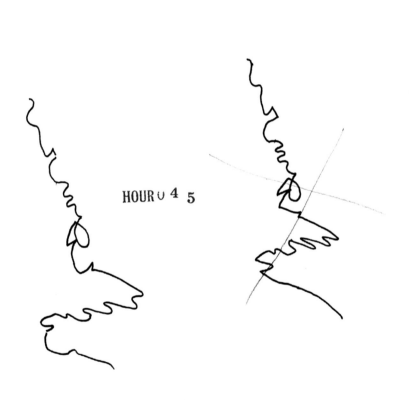

HOUR ∪ 4 5

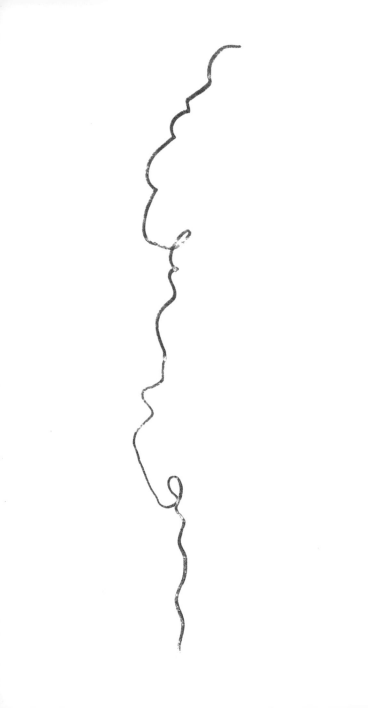

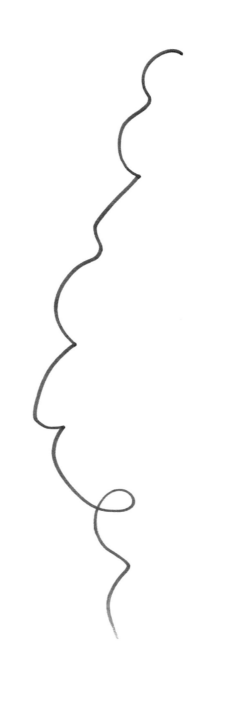

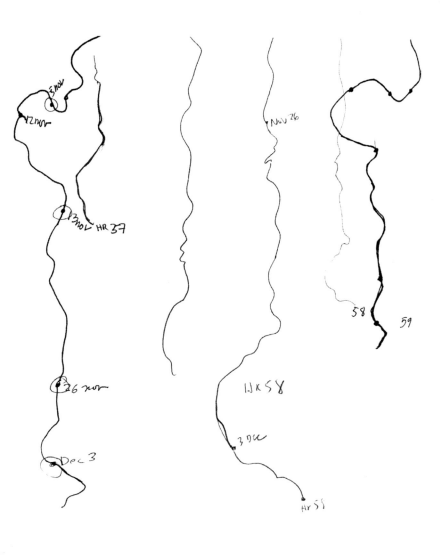

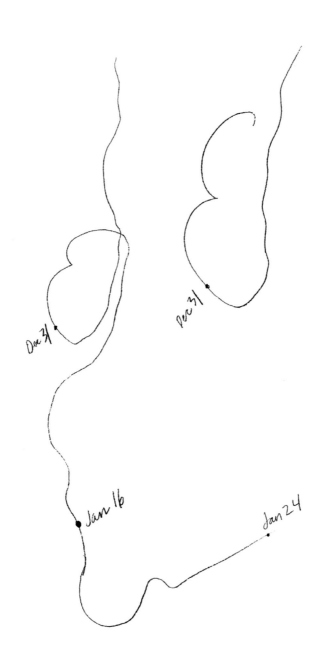

Dec 31

Dec 31

Jan 16

Jan 24

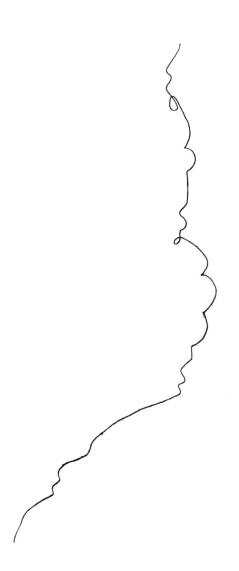

HOUR ∪ 7 6

NOTE

Although we are drifting, the ship's movement
is often invisible to the human eye. We're
just like the plankton (the only other form
of life up here besides the occasional polar
bear) as we have no control over our course, our
direction, our arrival. Since the future eludes
us it grows into an obsession. The majority
of us, upon waking up, take the two steps down
into the office and check the GPS coordinates,
and the satellite pictures of Tara's path,
as if we were reading the front page of the
newspaper while drinking our morning coffee.

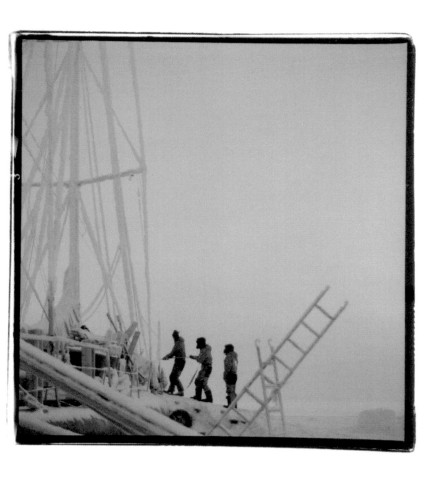

LOG OF LIMITS

(SNOW WALKS)

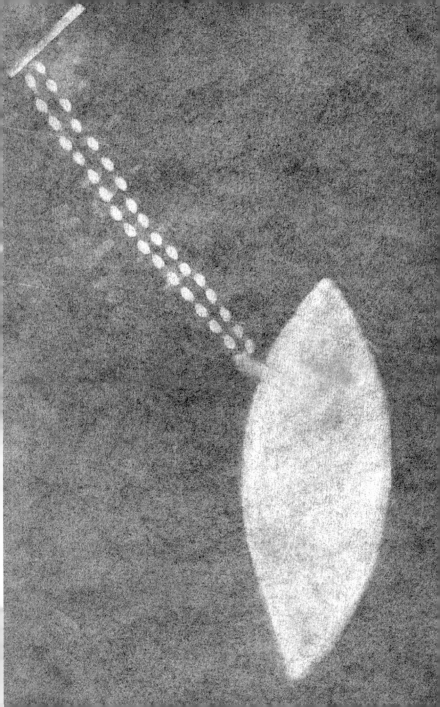

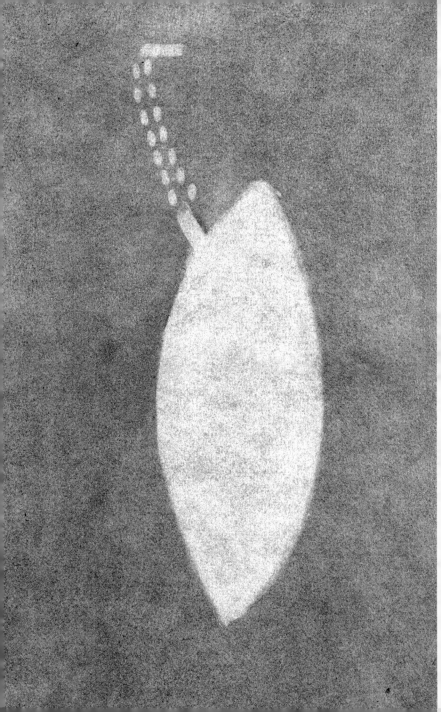

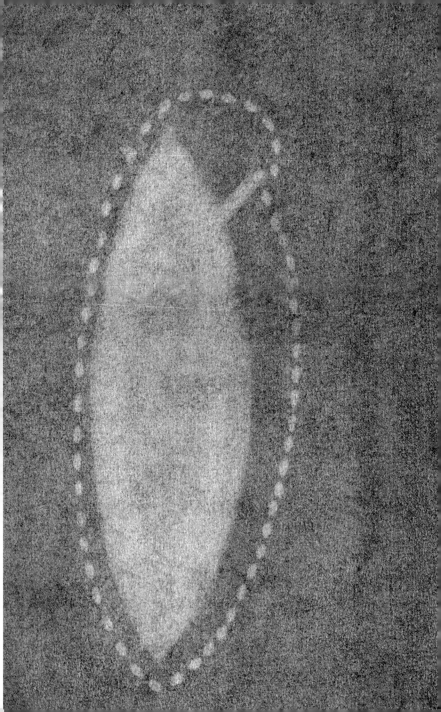

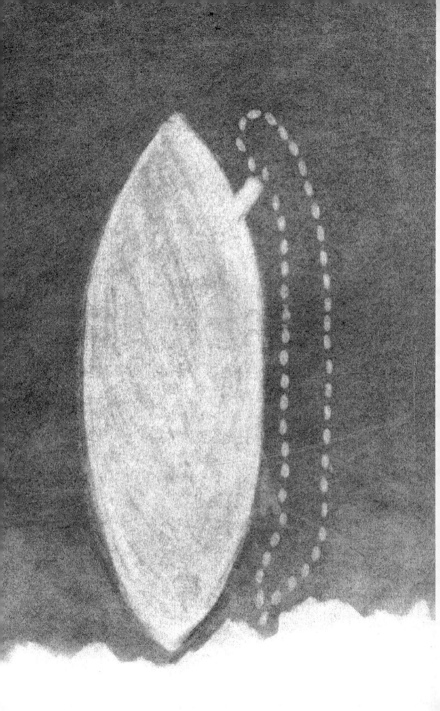

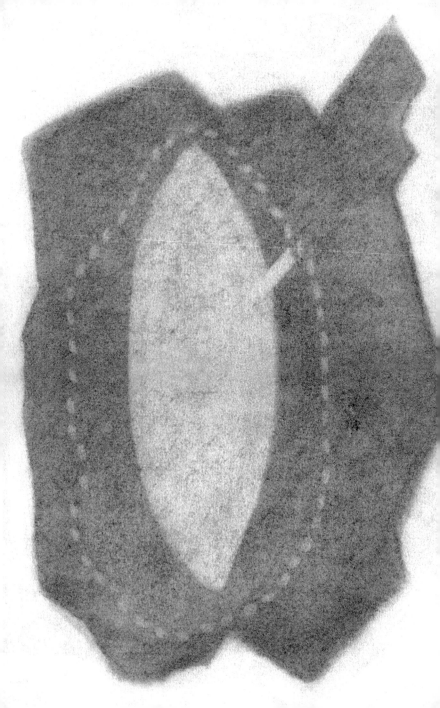

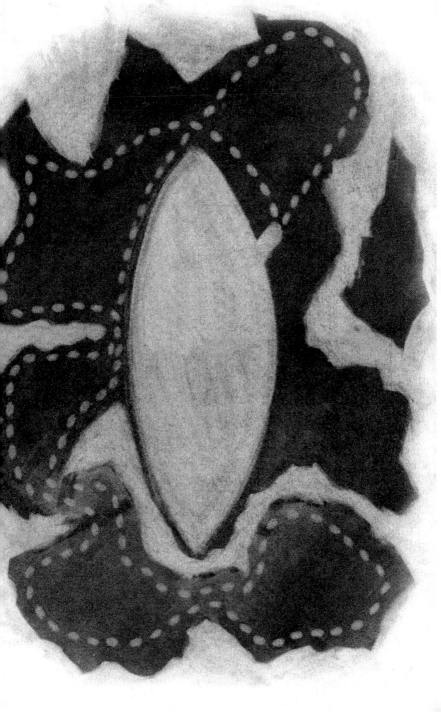

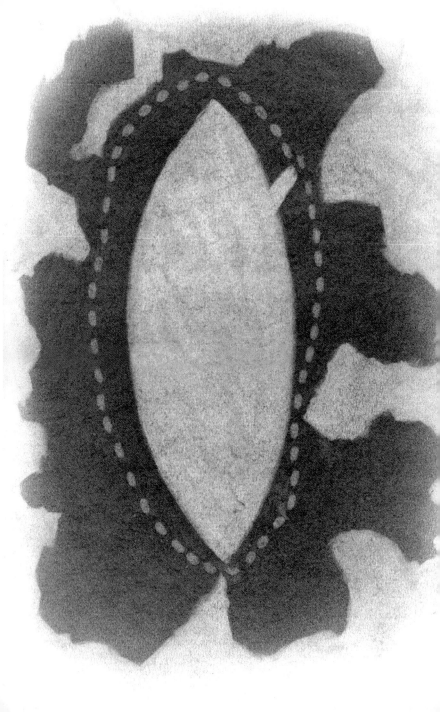

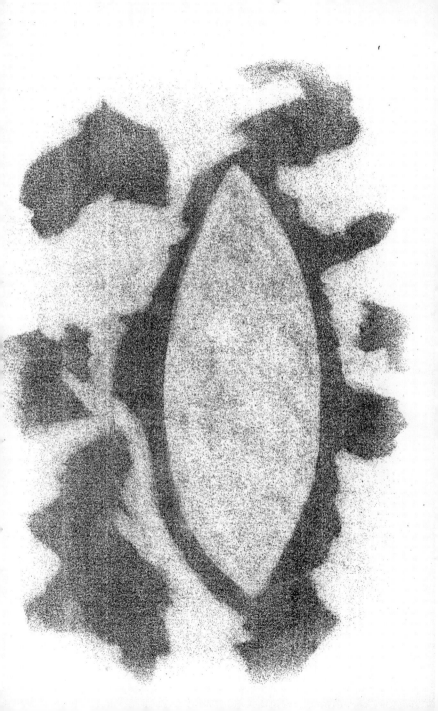

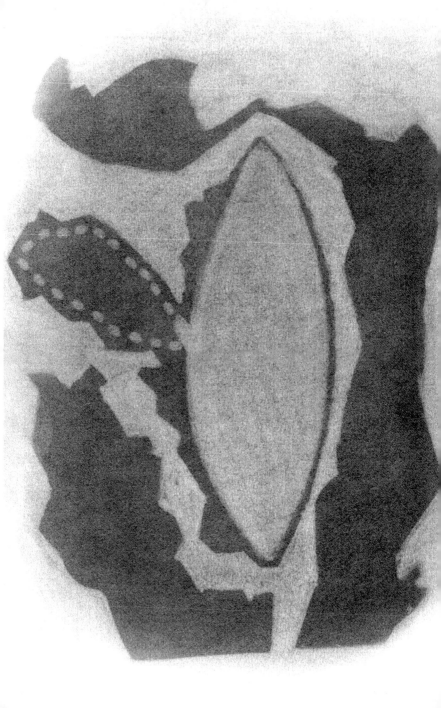

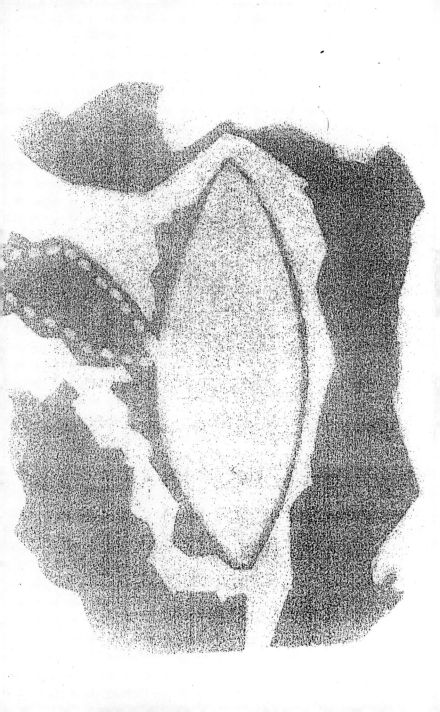

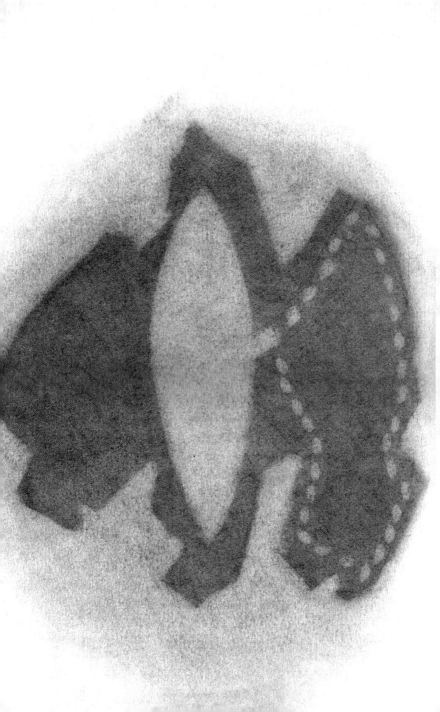

NOTE

Dec 11 9:30am: Took walk around Tara

Dec 11 6:00pm: Only starboard side of ice accessible

Dec 13: Tara tied to ice, 250 footsteps all around

Dec 15: Sufficient room on portside ice to tie up dogs and collect snow

Dec 17: No movement possible off Tara, walk dogs on bridge

Dec 19: The same

Dec 24: Starboard side accessible, ice moving slow enough to walk dogs 50 footsteps repeated five times

Jan 5: Possible to walk around Tara (but not advisable)

Jan 10: Possible to walk around Tara (but not advisable)

Jan 12: Possible to walk around Tara

Jan 17: Possible to play rugby around Tara

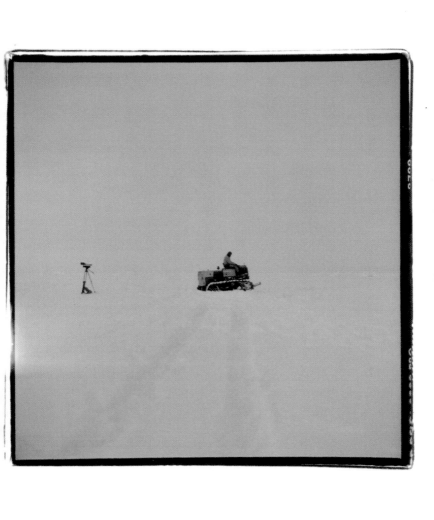

NORTH WAS HERE

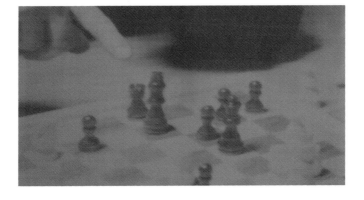

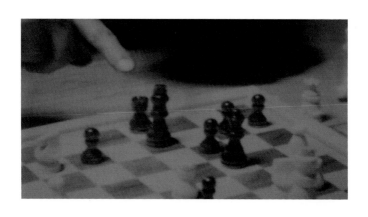

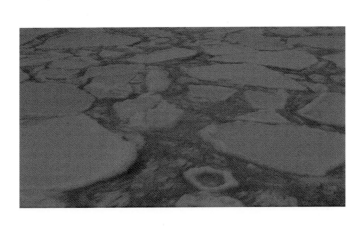

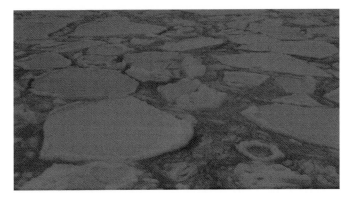

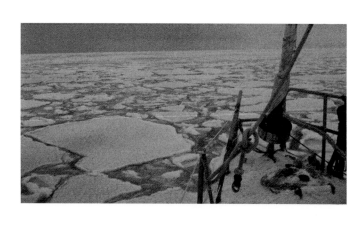

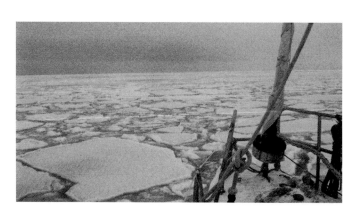

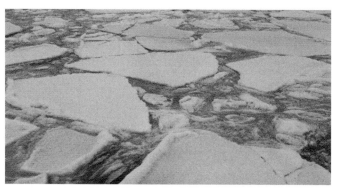

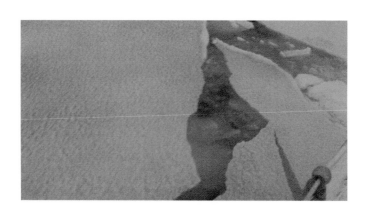

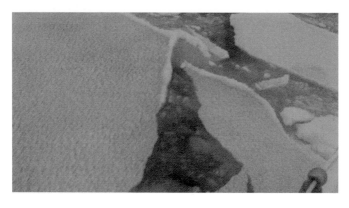

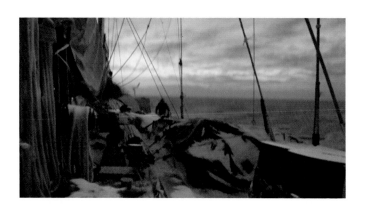

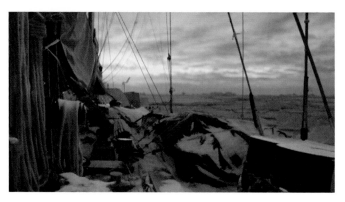

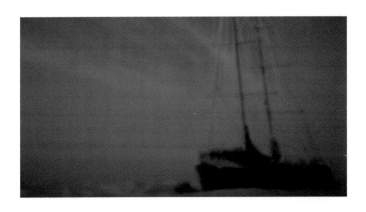

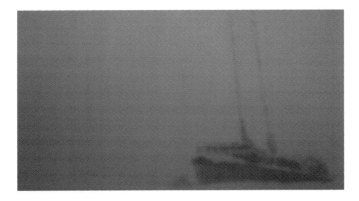

NOTE

When the ice released us on January 21,
appropriately enough we were in the Fram Strait
— a body of water between the Arctic Ocean and
the Greenland Sea — named after a Norwegian boat,
the *Fram*, which, 150 years ago, was the first
boat constructed to drift in the arcric ice.

By the time we had reached the Fram Strait, Tara
had drifted far enough south so that there was
an hour or so of twilight on the horizon. But
then we had to sail back north for three days,
in order to reach the Norwegian archipelago of
Svalbard where it would be complete night yet
again. It seemed like sailing back in time.

At our destination we were greeted by two
lights emanating from a lighthouse. As we
stood on the bridge watching these lights
from civilization come closer and closer,
the doctor turned to me and said, "You know,
I have a feeling you only get to to do this
once in your life and well, I have failed."